ALVAR AALTO APARTMENTS

From left to right: town director Lauri Kaijalainen, Alvar Aalto and director of the Housing Foundation Heikki von Hertzen in Korkalovaara, Rovaniemi at the beginning of the 1960s. In the background is a two-storey terraced house designed by Aalto.

RAKENNUSTIETO®

ALVAR AALTO APARTMENTS

PHOTOS JARI JETSONEN TEXTS SIRKKALIISA JETSONEN

Photographs, if not stated otherwise Jari Jetsonen
4, 108 Housing Foundation / 31 Keski-Suomi Museum / 41, 51 (photo Roos), 79, 90 (Heikki Havas), 109, 121, 141 Alvar Aalto Foundation / 65 Ezra Stoller / 91 Presse-Foto / 99 Tiofoto, Lennart Olson
Drawings Alvar Aalto Foundation
Pictures editors Sirkkaliisa Jetsonen and Jari Jetsonen
Translation Kristina Kölhi and Gareth Griffiths
Graphic design Janne Vesterinen
© Authors and Building Information Ltd
www.rakennustieto.fi
ISBN 951-682-732-2
Paper Maxisatin 150 g
Printers Kirjapaino Karisto Oy, Hämeenlinna 2004

CONTENTS

6 Foreword
Peter Reed

8 Alvar Aalto's Thoughts on Housing
Markku Lahti

17 The Core of Culture
Sirkkaliisa Jetsonen

21 Apartment buildings
"From doorstep to living room"

22 Aira Building, Railway officials' housing
Jyväskylä, Finland 1924–1926

32 ROT houses, 'Slope-door houses'
Sunila, Finland 1938

42 Standard terrace housing
Kauttua, Finland 1937–1938

52 Baker House, Senior Dormitory
Massachusetts Institute of Technology
Cambridge, USA 1946–1949

66 National Pensions Institute employee housing
Helsinki, Finland 1952–1954

80 Hansaviertel apartment building
Berlin, Germany 1954–1957

92 Housing and business complex, Sundh Centre
Avesta, Sweden 1955–1961

100 Korkalovaara apartment buildings
Rovaniemi, Finland 1956–1960
(Rakovalkea block 1958–1959, Poroelo block 1960)

110 Neue Vahr apartment building
Bremen, Germany 1958–1962

122 Harjuviita apartment buildings
Tapiola, Espoo, Finland 1961–1967

132 Student housing, Helsinki University of Technology
Otaniemi, Espoo, Finland 1963–1966

142 Schönbühl apartment building
Lucerne, Switzerland 1964–1967

154 Selected Information

Foreword

People love to look at houses, but not housing. Rarely, if ever, has the popularity readily accorded the private house and interior design – whether in the form of museum exhibitions, books or the huge number of so-called "shelter magazines" – extended to apartment buildings and housing. Housing ranks rather low in the architectural pecking order. Furthermore, its connotations are seemingly bereft of romance, curiosity, and architectural distinction. For an architect to take on the challenge of designing decent, middle-class housing one might assume that he or she has a particularly active social conscience. Perhaps this is an arrogant generalization, but how often has housing competed with a new concert hall, Kunsthall, or private house for architectural interest, particularly in the publishing industry?

As this new publication demonstrates, housing can be beautiful, typologically varied, and even assume a symbolic dimension usually associated with civic institutions. If Alvar Aalto had designed nothing else, his numerous projects for multiple family housing would alone merit study and close consideration. His housing designs remain relevant for many reasons, in part, because they transcend their local conditions and specific circumstances. The brilliance and influential potential of Aalto's housing are inherent in his belief that design must answer to fundamental biological conditions of human life – including adequate air, light, and connection with the ground. This means providing more than the "existenzminimum", which can create an environment where humans are treated as ciphers and where design is reduced to functional analysis exclusive of the psychological and biological domain that was central to Aalto's thinking.

Rarely has the industrialized world, or for that matter any civilization, achieved truly decent housing for the majority of its citizens. Too often the nemeses of intelligent planning and decent housing are the real estate speculator and cheapness, two antagonistic forces identified by Aalto. In 1957, he argued that the cheapest house is also the most inhuman: "For instance, we have ... the theoretical line of building economy, which is popularly stated in this way: 'What form of house is most economical? [...] What is the cheapest way we could give people badly needed houses?' Of course, this may be called science. But it is not [...] One can go further and say that the most inhuman house is the cheapest. [...] Real building economy cannot be achieved in this ridiculous way. The real building economy is how much of the good things, at how cheap cost, we can give. [...] But if you leave out the quality of the product, the whole economy is nonsensical in every field."[1] Aalto's housing demonstrates that when the basic quality of a product is not overlooked, design can often overcome economic shortcomings with results that are both beautiful and socially relevant.

Multiple family housing is ecologically and environmentally responsible when compared to other types of housing development. When housing is well designed and coupled with intelligent urban planning, resources are used efficiently while balancing needs for both community and privacy. The placement of Aalto's buildings in the landscape, and consequently their relationship to urban design and even regional planning, reminds one of the needs for balanced and sustainable land-use patterns. Aalto's concept of economical housing extended to the building environment as a whole. The innovative formal solutions and variety of designs in Aalto's apartment buildings give the work its visual strength. The stepped profiles, the fan-shaped plan, the undulating façade, balconies that are pulled into the building to provide a sense of shelter and protec-

tion ... these are some of the formal strategies that mitigate the monotony so often associated with housing. It is no coincidence that the six-story Baker House Dormitory for the Massachusetts Institute of Technology ... with its idiosyncratic room types and careful concerns for sun, view and privacy ... is the most popular residential hall on the university's campus. Students joke that it is harder to get a room in Baker House than it is to get accepted into MIT. The high-rise apartment building at Neue Vahr, Bremen, an atypical type in Aalto's oeuvre (he generally shunned high-rise living), has nonetheless become a symbol of the middle-class garden city the way a civic monument or historic institution becomes a symbol of a city. That an apartment building could achieve this status indicates the power of good design. Height alone cannot guarantee symbolic association. Rather, with its idiosyncratic fan-shaped profile, the Neue Vahr building is both beautiful to look at and pleasant to be in.

Cities and expanding urban regions throughout the world continue to face critical housing issues that range from the design of individual units to the buildings themselves to the urban scale. Despite our phenomenal technical abilities and advances, many of the same issues Aalto confronted fifty years ago have not been solved. Affordability, comfort, attractive buildings and sustainable urban design are advocated repeatedly and still in demand. In these endeavors, Aalto's work and thinking can inspire greater ambition and creativity and in so doing lead us to a beautiful and ultimately economical architecture that responds to real human needs.

Peter Reed
Curator of Architecture and Design
at The Museum of Modern Art, New York.

Sketches, Neue Vahr, Bremen

1 Alvar Aalto, "The Architectural Struggle,", RIBA Annual Discourse; speech given to the Royal Institute of British Architects, London, 1957; reprinted in Göran Schildt, ed., *Sketches: Alvar Aalto*, trans. Stuart Wrede (Cambridge, Mass., and London: MIT Press, 1978), p. 147.

Markku Lahti

Alvar Aalto's Thoughts on Housing

Alvar Aalto's oeuvre consists of approximately 500 works. Of all these, he is best known for his public buildings. The Paimio Sanatorium, the Sunila pulp mill, Säynätsalo town hall, the National Pensions Institute, numerous libraries and churches and two university campuses are all highly acclaimed. Less attention, however, has been given to his housing designs, even though he managed to design almost 100 single-family houses and the same amount of apartment blocks and terraced houses. Of these the most remarkable are Aalto's own home in Munkkiniemi in Helsinki and Villa Mairea in Noormarkku, which are regarded as important works in his oeuvre alongside his public buildings.

Why have Aalto's thoughts on housing received less attention? There are probably several reasons: the common habit of undervaluing housing design and perhaps also Aalto's own attitude, that is, he did not want to accept commissions from just anybody. Aalto's writings from the 1920s onwards reveal an architect for whom the ideas of creating a better world and social responsibility were important. The architect was to look to the past to see the seeds for the future, but he also had to strive to find through empirical research and rational thinking the means for taking into account the 'little man' and his needs in all design and building. Aalto finally arrived at a synthetic view, according to which, good architecture is never the result of just rational analysis: intuition and feelings equally direct the creative process. Aalto wrote in 1957: "Residing in a place is, per se, one of the great mysteries of human life. Why is the poor human creature fated to work, eat and live in a dwelling? Not all animals, for instance, live in fixed abodes, but all animals without exception feed. The housing problem is without doubt one of the most important we have to resolve. Our entire culture rests on the nature of our dwellings."[1]

MOTIFS FROM PAST AGES

Aalto wrote about housing already in his early newspaper columns from the 1920s. His ideals were found on the one hand in the small town and its everyday life and on the other hand in Italian urban culture. In 1921, at just 23 years of age, he wrote: "I still think a small town is the most wonderful of all communities on Earth, the only place where life can offer anything like concentrated colour and life to an inquisitive boy."[2] Particularly the markets and public squares, people's public living rooms, attained an important place in his writings and architecture.

Jämsä Church, competition entry, 1925.

Another theme closely related to housing and urban culture came to the fore after his honeymoon trip to Italy in 1924, when the hill town so typical of the Mediterranean culture became a lasting feature in his writings and architecture. He wanted to make his home town of Jyväskylä into a Nordic Florence, placing all new buildings on the slopes of hills. At the same time he emphasised the 'mark of man' as a harmonic element in the landscape.

One also finds other themes in Aalto's writings from the 1920s which refer to things to come. In "Motifs from past ages", from 1922, he writes as if describing his own buildings: "When entering our old churches, gazing at a Gustavian country manor or examining a century-old work of rural handicraft, we are seized by emotion. No doubt this is partly due to the trace of human handwork on the surface, the artistic purity of building materials or the simple lines adapted to our landscape; on the other hand it also has to do with the signs of wear and centuries of patina in the building material."[3] Also Aalto's move to functionalism or rationalism was a more natural step than some have wanted to acknowledge. He wrote in 1925: "The only real objective of architecture is: build naturally. Don't overdo it. Don't do anything without good reason. Everything superfluous turns ugly with time."[4] Already four years earlier he had written: "The more social the art – and architecture is one of the most social of arts – the more collective the spirit, the participation of the environment and the whole epoch, in the work it involves. The striving to give one's best can come to fruition only in these conditions."[5]

Aalto's most important writing concerning housing design is an article from 1926 in the magazine *Aitta* titled "From doorstep to living room". Its central messages are linked on the one hand with the northern climate, which is taken into account in the design of the spatial layout, and on the other hand to the concept of human weakness, something he returned to in his writings as late as the 1970s. Aalto criticised the fact that the knowledge did not exist in Finnish building to place the building correctly in the landscape, and that the connection between the interior and exterior spaces was badly resolved. His 'unattainable domestic culture ideal' came from the southern European conceptualisation of space, where the garden formed a substantial part of the home: the external wall is not the wall of the building but the wall of the garden. Indeed,

1 "Schöner wohnen" [More beautiful housing], lecture in Munich, 1957. Reprinted in Göran Schildt (ed.), *Alvar Aalto in his own Words* (Keuruu: Otava 1997), p. 261.
2 "Eldorado", article in *Kerberos* No. 3, 1921. Schildt 1997, p. 14.
3 "Motifs from past ages", article in *Arkkitehti* No. 2, 1922. Schildt 1997, p. 33.
4 "Temple baths on Jyväskylä ridge", article in *Keskisuomalainen*, 22.1.1925. Schildt 1997, p. 18.
5 "Our old and new churches", article in *Iltalehti*, 14.12.1921. Schildt 1997, p. 36.

the opening of the spaces southwards and toward the light was one of the central themes in Aalto's housing designs, for both single-family houses as well as apartment blocks.

On the other hand, in the Nordic climate the face of winter is also important in the home, the interior design emphasising the warmth of the rooms. Aalto wanted to create internal spaces in which the open fireplace, coarse floor surfaces and the treatment of forms connected to the external architecture make the internal space "an allegory of the open air under the home roof". He wrote: "The hall as an open-air space can form a piece of the philosopher's stone, if correctly used. I hand it to my reader in a locked casket, and ask his pardon if I should fail to provide him with the key. For the same reason as I previously wished to turn your garden into an interior, I now wish to make your hall into an 'open-air space'."[6]

At the end of the article Aalto also presents some words of wisdom that now and again reappear in his writings over the years: "But if you want my blessing for your home, it should have one further characteristic: you must give yourself away in some little detail. Your home should purposely show up some weakness of yours. This may seem to be a field in which the architect's authority ceases, but no architectural creation is complete without some such trait; it will not be alive."[7]

THE CHALLENGES OF THE WELFARE STATE

In 1927 Aalto 'turned' to become a supporter of rationalism, both in his writings as well as in his architecture. There are many natural reasons behind this seemingly sudden change. From his home and school he had inherited a belief in progress and the development of technology based on enlightenment philosophy. The actual push giving the change in thinking was, however, his architect friends Gunnar Asplund and Sven Markelius, who were both involved in building Sweden into a social democratic 'home for the people' [in Swedish 'folkhem']. It was also through them that Aalto came to join CIAM, the core group in international modernism. He became familiar with the ideas of the Bauhaus and Le Corbusier, and with all the keenness of a 30-year-old threw himself into the new wave of functionalism and rationalism, changing the foundations of architecture. This same wave lifted him in the beginning of the 1930s to international fame.

6 "From doorstep to living room", article in *Aitta*, 1926. Schildt 1997, p. 53.
7 Ibid., p. 55.

Villa Mairea,
sketch for the exterior fireplace.

Even though Aalto's rationalism can come across in the light of his writings as fairly simple, critical comments can also be discerned here and there as early as 1928. He uses the concept of 'new realism' rather than rationalism, thus emphasising the practicality of the architect's work. In 1927 he wrote about the building form corresponding to its purpose: "A building must serve either god or man; it cannot be the shell of an idea, least of all an allegory."[8] And the following year he wrote: "Thus we cannot create new form where there is no new content."[9]

One of the central aims of the Nordic welfare society was to create an equal, classless society in which each citizen is guaranteed equal opportunities to, among other things, health care and education irrespective of social position. Also the position of the family and women in society changed. The number of women in the working population multiplied and as a result, for instance, childcare had to be arranged by society.

The changes set new demands also for the urban domestic culture, the values of which emphasized healthy and modest everyday living and its needs. In its functionalist architecture and artefact design, the Stockholm Exhibition of 1930 was right on the pulse of the times in Europe. It had repercussions also in Finland. Aalto wrote two positive articles about the Exhibition. That same year he participated in arranging a "Minimum Apartment Exhibition" in the Kunsthalle in Helsinki.

ANALYSIS AND RESEARCH

Aalto's article "The Housing Problem" from 1930 was his rationalist manifesto for solving the housing problem. In it he wrote: "No family can live in one room, not even in two if it has children. But any family can live quite well in an area of the same size if that area is divided with a view to the life of the family and the activities of its members. A home is an area that forms a sheltered space for eating, sleeping, working and playing. These biodynamic forms must serve as the basis for the internal divisions of a home, not obsolete symmetrical axes and 'standard rooms' dictated by facade architecture."[10] The design must therefore have its starting point in real spatial needs, and it must also take into account the flexibility of the spaces. Here Aalto adopted the Bauhaus way of thinking.

A large size dwelling was in Aalto's opinion not an advantage, but rather a disadvantage. The starting

8 "An Independence Monument in Helsinki – The Olympic Stadium", article in *Uusi Suomi*, 25.11.1927. Schildt 1997, p. 65.

9 "The latest trends in architecture", article in *Uusi Aura*, 1.1.1928. Schildt 1997, p. 62.

10 "The housing problem", article in *Domus*, No. 8–10, 1930. Schildt 1997, p. 77.

Fig-tree branch, 1951.

point of his analysis was the minimum dwelling which gave a functional apartment when it was increased in size according to need. Aalto's idea was epitomised in his comment about the kitchen: "What housewife these days wants a large kitchen? A wise housewife wants a kitchen that is good to work in – that is, a kitchen from which all unnecessary space has been removed."[11] Furthermore, he wrote of "a relaxed everyday life in which irrelevant points only produce a comic effect."[12]

Research was an integral part of Aalto's analytical design process, the importance of which he still emphasized in his writings in the 1950s. In "The Housing Problem" he took a more practical angle to research: "There is no sense in studying the question of what are the poorest conditions in which people can still survive; [...] The question we are asking today is this: what demands must be on an apartment, its production and consumption, given that it must fulfil (at the minimum subsistence level) the full requirements of social positiveness?"[13] Biological requirements were, for instance air, light and sun, the importance of which Aalto continuously emphasized. Air quality was for him primarily a plan related issue, not a matter of room size. The sun brought energy and had to be brought into every apartment. Aalto gave the following critical comment on town planning: "Town planning is based on a mistaken veneration of antiquity on emotional and imaginary aesthetic grounds."[14] Also, in his opinion: "Quite simply, every home must be technically planned so as to include an accessible outdoor area, and to correspond biologically to nature, to which man was accustomed before the advent of cities."[15] Aalto had presented this same thought already in his writings from the 1920s.

Aalto's radical and progressive way of thinking was seemingly in conflict with his world view that emphasized the value of the individual. He was not a revolutionary supporter of mass movements. In a lecture at the RIBA in London in 1957 Aalto stated: "The architectural revolution is still going on, but it is like all revolutions: it starts with enthusiasm and it stops with some sort of dictatorship."[16] From the 1930s onwards the concept of the 'little man' recurs in his writings; an individual, whose tragedies and comedies were always close to Aalto's heart. He ends the "Housing Problem" as follows: "… each member of the family must be provided the opportunity for complete isolation within the

11 Ibid., p. 78.
12 Ibid.
13 Ibid., p. 80.
14 Ibid., p. 81.

15 Ibid., p. 82.
16 "The enemies of good architecture", RIBA Annual Discourse, London, 10.4.1957. Schildt 1997, p. 202.

Sketch study of the rooflights for Viipuri Library c. 1930.

home walls. Even here we thus cannot operate with the concept of the room, but come to half-rooms and systems in which isolation (say as provided by bedrooms) and joint living areas can no longer be solved by emotionally based group concepts, axes of symmetry or the like."[17] And finally he mentions the influence of the position of women: "The new independence of women gives rise to entirely new requirements in work amenities, ease of cleaning, and the weight and mechanical viability of objects within the home."[18]

Aalto became aware already early on of rationalism's weaknesses. He warned against the dangers of uniformity and formalism, which in architecture led to psychological slums. "Objects that can rightly be called rational often suffer from a flagrant inhumanity",[19] stated Aalto in a 1935 lecture. He also criticised planning for formalism and proposed that "... all regulations aimed at superficial, formal standardization must be rejected. [...] Instead of schematism, town plans should provide true freedom to grow; they should form a flexible system for controlling the growth of society."[20]

Aalto was nevertheless ready to admit that standardisation was the only way in which the housing problem in society could be solved. For him standardisation meant instead of uniformity an organic richness, the model for which could be found in nature. "Contact with nature and the ever-enjoyable variation it produces is a way of life that makes them reluctant to dwell too long on formalistic concepts",[21] stated Aalto in 1935. He saw Japanese culture as a model example for the architecture of housing, the refinement and sense of the individual of which he appreciated.

THE MYTH OF NATURE

Aalto had a profound relationship to nature. To him it meant the purity of materials and shapes, functioning at the same time as a model for standardisation. In regards to the exemplariness of nature and the dialectic relationship of the countryside and city he wrote in the mid-1930s that: "...nature herself is the best standardization committee in the world..."[22] In nature the smallest standardised unit is the cell and this should be applied in architecture, too. Aalto wanted to emphasise that "...variety and growth reminiscent of natural organic life are the very essence of architecture. I would like to say that this is ultimately the only true style in architecture. Set up obstacles to it, and architecture will wither and die."[23]

17 Schildt 1997, p. 83.
18 Ibid., p. 84.
19 "Rationalism and man", lecture in Stockholm, 9.5.1935. Schildt 1997, p. 90.
20 "Influence of structure and material on contemporary architecture"; lecture at the Nordic Building Congress, Oslo, 1938. Schildt 1997, p. 101.
21 Schildt 1997, p. 93.
22 Ibid., p. 101.
23 Ibid.

In a speech Aalto held in Sao Paulo, Brazil, in 1954 he returned yet again to this theme, putting his message concisely: "It will be more and more difficult for the little man in society to select his own way of living. A too-commercialized standardization will turn him into a piece of machinery, a robot. (...) In the same way as we speak about elastic planning, we may also come to speak of elastic standardisation, where the benefits of industrial methods are synchronized with the chance of creating rich variety instead of uniformity."[24]

Nature represented for Aalto, as indeed for many other Finns, clean air and water, independence, solitude, peace and quiet. But the paradox created by untouched nature and urban housing lay deep within him. In his view, nature is refined only through the architect: "...pure, original nature, with all its magic power, cannot surpass the sight of a landscape to which a human touch has been added as a harmonious, enhancing factor."[25] And yet, on the other hand, he wanted to bring nature close to architecture. He accepted high-rise building only where low-rise building was not possible. He justified his placement of, for instance, the Heimdal apartment block (Nynäshamn, Sweden) on a slope, with the explanation that not a single storey would rise too high and nature would be as close as possible to each apartment. The recessed atrium balconies of the Berlin Interbau multi-storey apartment block function as a kind of continuation of the external space and nature into the interior. Aalto's aim was to develop a multi-storey building culture in which life would be as similar as possible to that in a private single family house.

Aalto defended humanism and continuously warned against the dominance of technology and planning threatening society. "Excessive planning tends to destroy the automatic forces of life", he stated in a 1949 speech, ending with: "Nature is a symbol of freedom. Sometimes it is actually the source of the concept of freedom, and its maintainer. By basing our technical master plans firmly on nature, we have every chance of turning the tide, making our daily work and all its forms increase freedom, rather than reduce it."[26]

THE ETHICAL RESPONSIBILITY OF THE ARCHITECT

Already Aalto's early writings from the 1920s reveal that he understood the role of the architect as a responsible servant of society and as a renewer. 'The lit-

A study of a patients' room
in Paimio Sanatorium.

tle man' was for him no mere phrase but contained a deep humane thought: "Architecture, too, has an ulterior motive always lurking behind the corner, the idea of creating paradise. That is the only purpose of our buildings. If we did not carry this idea with us all through our lives, our buildings would all be simpler and more trivial, and life would be – well, would there be life at all? Every building, every architectural product that is its symbol, is intended to show that we wish to build a paradise on earth for man."[27]

Aalto's role as a reformer received a specific impetus at the end of the 1920s when he internalised the challenges set for architecture by the welfare society. In his opinion, necessary quantitative aims could not be achieved without standardisation; but this again often led to qualitatively weak results. In a lecture given in London in 1950 he stated: "It is very difficult to socialize equally throughout the world and to divide quality and quantity between everybody. I do not think we could do it better or with better tools than Christ did at the wedding at Cana, where he mixed water with red wine."[28]

Research became an important part of Aalto's work already in the 1920s; in his opinion, it was an important means to promote architecture. He complained that for economical reasons it is not possible to experiment in architecture in the same way as it is in other 'arts'. In every project, however, there should be, according to him, at least a little bit of experimentation, thus taking architecture forward.

In Aalto's opinion even luxury housing developments can be justified when they are used as experimentation areas and laboratories. He wrote of Villa Mairea in *Arkkitehti* [Finnish Architectural Review] in 1939: "The individual architectural assignment can be treated as a laboratory experiment of sorts, in which things can be done that would be impossible with present-day mass production, and those experiments can spread further and eventually become available to one and all as production methods advance."[29] Aalto built his own experimental house in Muuratsalo at the beginning of the 1950s.

Aalto's most extensive research and experimental project was "An American Town in Finland", began in 1940 in MIT, the background to which had been the problem of re-housing war refugees. Even though the actual laboratory plan was not realised, Aalto published an extensive report the following year in which he

24 Lecture in Sao Paulo, 1954. Schildt 1997, p. 138.
25 "Architecture in the landscape of Central Finland"; article in *Sisä-Suomi*, 26.6.1925. Schildt 1997, p. 21.
26 "Finland as a model for world development"; keynote speech in Helsinki, 27.2.1949. Schildt 1997, p. 171.
27 "The architect's dream of paradise", lecture in Malmö, 1957. Schildt 1997, p. 215.
28 "Finland wonderland"; lecture in London, 20.6.1950. Schildt 1997, p. 185.
29 "Mairea", architectural description in *Arkkitehti*, No. 9, 1939. Schildt 1997, p. 229.

also summarized his thoughts: "Standardization here does not mean a formal one with all houses built alike. Standardization will be used mainly as a method of producing a flexible system by which the single house can be made adjustable for families of different sizes, various topographical locations, different exposures, views, etc. This means that practically every house will be different from its neighbour, in spite of the fact that there will be a strict standardization of elements and building cells."[30] Aalto's partly prefabricated houses following standard type plans were manufactured during the 1940s and several hundred of them were erected in different parts of Finland, particularly in factory communities.

As a counterweight to research and experimentation Aalto emphasised the importance of play in the creative activity which architecture represents. In a text from 1953 presenting his Muuratsalo experimental house he wrote: "Only when the constructive parts of a building, the forms derived from them logically, and our empirical knowledge is coloured with what we might seriously call the art of play, only then are we on the right path. Technology and economics must always be combined with a life-enhancing charm."[31]

Aalto was no theoretician. Beauty, comfort, form and many other concepts of architecture and aesthetics are, however, a part of his vocabulary. Of beauty he wrote that it is "the harmony of function and form".[32] Form, again, he described as: "... nothing else but a concentrated wish for everlasting life on earth",[33] and later: "form is a mystery of which we cannot tell what it really is, but somehow it makes people feel good in a way that is completely different from what efforts at social salvation can do".[34]

Aalto wrote that "we must be tactful with nature, that we must foster life – though using technical means".[35] Nature was for him a wide concept. Its core was man, the existence of whom, however, was often forgotten. "And architecture – the real kind – only exists where the little man is at the centre. His tragedy and his comedy – both of them."[36]

30 "An American town in Finland"; article in *Journal of the Royal Institute of British Architects*, 17.3.1941. Schildt 1997, p. 130.
31 "Experimental house at Muuratsalo"; building description in *Arkkitehti*, No. 9–10, 1953. Schildt 1997, p. 234.
32 "Modern architecture and interior design of the home"; article in *Uusi Aura*, 21.10.1928. Schildt 1997, p. 256.
33 "Abbé Coignard's sermon"; lecture in Jyväskylä, 6.3.1925. Schildt 1997, p. 57.
34 "Between humanism and materialism"; lecture in Vienna, April 1955. Schildt 1997, p. 180.
35 Interview for Finnish Television, July 1972. Schildt 1997, p. 274.
36 "In lieu of an article"; article in *Arkkitehti*, No. 1–2, 1958. Schildt 1997, p. 264.

Sirkkaliisa Jetsonen

The Core of Culture

THEMES IN ALVAR AALTO'S RESIDENTIAL ARCHITECTURE

"OUR ENTIRE CULTURE RESTS
ON THE NATURE OF OUR DWELLINGS" [1]
The starting point of Alvar Aalto's architecture was the principle of creating a good framework for everyday life. Ideas about the essence of the home and dwelling, which he presented in numerous writings from the 1920s to the 1950s, were realised in his designs and buildings. Sometimes the buildings were completed at more or less the same time as the writings, but quite often the germ of an idea was realised only years later. Of course, many factors define housing design: the building regulations, the economic conditions, and (particularly for apartment blocks) the regulations regarding grouping and repeatability. Through small nuances Aalto was able to create even within an ordinary apartment an ambience and character. Aalto's design philosophy can be seen in the buildings themselves.

The themes filtering from Aalto's writings into the designs of his buildings can be divided into two main groups: the internal arrangement of the apartment and the relation of it to the exterior world. Both themes were present already in the 1920s in his article "From doorstep to living room" (1926)[2], which is an important essay in Aalto's production from the point of view of housing design.

Aalto gave greater attention to the internal layout of an apartment than was the custom at that time, when the internal space was usually simply divided into rooms or room sequences. His ideas were crystallised in the concepts of the centrally placed hall and structurality as the organiser of the interior. The central hall was a successor of the atrium of antiquity and it linked Aalto's modern solutions to a long chain of tradition. The hall could be interpreted and varied in numerous ways. It was the symbol for the outdoors and fresh air. It was the heart of the dwelling, "pure space" around which other spaces were assembled, and from which views to the exterior opened. The atrium house (1925) that Aalto designed for his brother, but which was never built, is the purest example of the idea of such a hall. Instead of decorativeness, what was important in the building was structurality, a domestic character, as well as the meeting of the two. The walls, with their openings, represent structurality, while the carefully considered interior, as well as the furnishings, represent domesticity and humanity. Already in the 1920s the interior and the placement of the furniture became for Aalto an essential part of the overall design.

A third theme, the idea of moving from one space to another, is closely linked with the two previous

Hall perspective of
Aalto's Atrium House, 1925.

themes. The play of outside-inside, which is typical for Aalto's buildings, existed in an embryonic form already in the 1920s. In the very title of the essay "From doorstep to living room" Aalto highlights the 'space between', the point of passage between the outside and inside, which in itself is an essential part of the building. He extended the position of the main entry, such that it now began already with one's arrival into the courtyard, and he wanted to "make an interior out of the garden". Correspondingly, he emphasised that the outside space continued into the very core of the building or apartment. The ideal was an open connection between the room, the building facade and the garden. The bourgeois apartment based on a formal room placement belonged, in his view, to a bygone world, a world he criticised particularly in the 1930s.

The Aaltos' own house in Helsinki, completed in 1936, contains the elements of an ideal apartment. The living room forms the heart of the house, around which the other residential spaces and the office form a frame and into which they open in various degrees. The house welcomes visitors, at the front courtyard and accompanies them through the building into the garden. The organic form, culture and the nature aspects which Aalto highlighted in his writings from the 1920s onwards are realised in this building in an uncontrived way.

A fourth early theme was the 'city', which emerged from the Aaltos' trips to Italy, especially the idyllic small towns that had grown freely in the hill terrain. Aalto applied his view of 'the city on the hill', for instance, in his design for the Kauttua stepped terraced housing in the 1930s, in which the historical interpretation and nature (the Finnish forest landscape) meet. Aalto created urban space by gathering together individual buildings in clusters around a public square – a 'piazza'. The same idea of urban space is repeated in miniature in the buildings themselves, as internal streets and square-like lobbies, forming a weave of public and private spaces. The variations of 'urban space' can also be seen as an interpretation of an open exterior space.

"EVERY HUMAN BEING
MUST LIVE SOMEWHERE." [3]
In the 1930s Aalto pondered on the potential of rationalism. Typical for the time, analysis and technology were considered as tools towards creating a better environ-

1 Alvar Aalto, "Schöner wohnen" [More beautiful housing], lecture in Munich,1957. Reprinted in Göran Schildt (ed.), *Alvar Aalto in his own Words.* Translated by Timothy Binham. (Keuruu: Otava 1997), p. 261.

2 Alvar Aalto, "From doorstep to living room", *Aitta*, 1926. Reproduced in Schildt 1997.

A point block in the Heimdal residential area. *Arkkitehti* 7–8/1946.

ment for all. The problematics of the minimum-sized dwelling were diligently studied and solved. Aalto's solutions involved flexibility and collectivism on many levels. He wrote in 1930 that the smaller the house is, the more everyday activities must be transferred to joint-access areas.[4] On the other hand, even a small apartment was to provide the flexibility for many different functions. There was no room for waste. Flexibility materialised in the suitability of a space for the different circumstances in people's lives, but also in favouring lightweight furniture. Slender furniture made a small apartment larger, both visually and functionally. Alvar and Aino Aalto looked in depth at the planning and furnishing of a small apartment in connection with the minimum apartment exhibition held in Helsinki in 1930. It was one of the contributing factors for his designs of standard furniture.

In 1929 Aalto participated in the second CIAM (Congrès Internationaux d'Architecture Moderne) Congress in Frankfurt, which dealt with the issue of the minimum dwelling. The presentations by Le Corbusier and Pierre Jeanneret, in which they highlighted biological needs and standardisation, made an impression on Aalto.[5] Aalto described with the concept of "biodynamic form" the spaces required in an apartment by a family and each individual for such functions as sleeping, eating, working and playing. The minimum dwelling both revealed and clarified the problems. The demand for air, light and sun, which were all slogans of functionalism, meant for Aalto also the biological prerequisites for human life. In his designs from the 1930s onwards, he oriented ever more purposefully the apartments towards the predominant sources of light. He also wanted to secure the design prerequisites for healthy and comfortable living through urban planning, through an organic city.

Instead of superficial comfort Aalto demanded "real feasible values for man's everyday well-being". Typical of his all-encompassing attitude, Aalto looked at the problematics from many angles: for instance, he saw culture as a balanced mentality born specifically from uncomplicated everyday life. Fresh outdoor air received a new meaning in the 1930s; it was idealised and strived for. Aalto emphasised the space outside the walls of the apartment, the 'outdoor part', as an important part of the home. It became ever more clearly the equivalent of nature. From the 1930s onwards, a balcony or terrace, as a continuation of the indoor spaces

3 Alvar Aalto, "The housing problem", *Domus*, No.8–10, 1930. Reproduced in Schildt 1997, p. 80.

4 Alvar Aalto, "The Stockholm Exhibition". *Arkkitehti*, 8/1930, p. 120. Reproduced in Schildt 1997, p. 75.

5 Elina Standertskjöld, "Alvar Aalto and Standardisation". *Acanthus* 1992. The Art of Standards. (Helsinki: Museum of Finnish Architecture, 1992), pp. 77–81.

of the apartment, became an essential part of the principles behind Aalto's housing designs. Similarly, Aalto was not in principle in favour of building high rise buildings, because he wanted to preserve the immediate connection to the terrain and to nature. His experimentations in the development of a stair-less multistorey building emerged from such thinking. In regards to apartments for families, as many as possible, he argued, should have an immediate connection with nature. Aalto's starting point in high-rise building became the point block, with its variations, containing small apartments for single people and childless couples.[6]

The above-mentioned themes are evident throughout many of Aalto's designs and completed buildings. Standardisation and variation were starting points already in the Tapani Standard tenant housing built in Turku in 1927. Some of the internal partitions in the smallish apartments, of different sizes, were light and moveable, thus allowing for a possible change in the room arrangement. Multistorey housing built in different parts of Finland in connection with several industrial communities consisted usually of groups of lamellar blocks placed skilfully in the natural landscape.

The only tower block project actually carried out in Finland according to Aalto's design was the Viitatorni tower built in Jyväskylä in the 1960s. As a stepped point block, it follows the design principles of the Neue Vahr house (1962) in Bremen. In the Hansaviertel house (1957) in Berlin, Aalto was able to realise several of his design ideals. In this building he also presented a specific solution for a multistorey building in which each apartment would have the physical properties of a single family house. The block offers in an uncontrived way a series of spaces ranging from public to private. In its ideal manifestation it is possible to walk from the square-like space of the entrance hall to the 'streets' of the upper floor levels, and to move into the sphere of the home via one's own 'front space'. The ideal of 'From doorstep to living room' materialises.

6 "The housing problem", op. cit. p. 79, 82.

APARTMENT BUILDINGS

"From doorstep to living room"

The design for an experimental town, 1940.

Jyväskylä, Finland 1924–1926

AIRA BUILDING | RAILWAY OFFICIALS' HOUSING

The housing for railway officials situated in a part of Jyväskylä north of the town's grid plan was the first building by Aalto where he familiarised himself with lower middle-class housing conditions. The three-storey building is placed along the street, though the entrances to the three stairwells are placed on the rear yard side. Only one type of apartment is used throughout, comprised of two rooms plus a kitchen, and which extends the whole depth of the building. On each storey there are two apartments placed symmetrically either side of the three stairs. A trace of 'bourgeois' housing is evident in the fact that there are two entrances to each apartment. Even though the apartments are simple and typical of their time, their spatial character has been enriched by small details: a curved recess for clothes in the entrance hall, the sides of the door openings between the rooms have been angled, and a 'fake perspective' has been created in the wall between the kitchen and bedroom. At the time of its completion Aalto wrote an article "From doorstep to living room" (1926) in which he emphasised how important it was that the structure of a house and its domestic character have a point of contact. Such an idea was realised in the Aira building, for instance, in the design of the openings between the rooms, the chamfered surfaces emphasising the structure as an essential part of the space.

The exterior walls of the distinctly object-like building are finished with an almost transparent render, beneath which one can distinguish the unevenness of the brick surface. The spirit of 1920s classicism is conveyed through small, almost abstract, and even humoristic details, such as the strongly coloured eaves soffit, the spiralling vine decoration painted along the downpipes and the arch motifs above the external doors.

The colours and decorations of the details in the Aira building, as seen in the eaves soffit, the downpipes and lamps, enrich its simple basic volume. Their delicate forms contrast with the rough and animated surface of the external brickwork. The strong green and red of the eaves soffit are typical of the classicism of the 1920s.

An interior view of the two-room apartments showing the connection between the rooms. Both morning and evening sunlight enter the apartments, which extend the whole depth of the building. The 'fake perspective' between the living room and bedroom concretises the 'principle of structurality' that Aalto emphasised in the 1920s.

RAUTATIELÄISOSAKETALO

PIHA FASADI ARKIT. ALVAR AALTO

I, II JA III KERROS

KELLARIKERROS

RAUTATIELÄISOSAKETALO
UUDISRAKENNUSPIIRUSTUS TONTILLE N:o 1
31:ssä NELIÖSSÄ JYVÄSKYLÄN
KAUPUNGIN II:ssa OSASSA

<< An elevation of part of
 the yard façade 1:250.

<< The basement and ground/first/
 v second floor plans 1:400.

 < A cross-section 1:250.

 v A view of the yard side soon after
 the completion of the building.

Sunila, Kotka, Finland 1938

ROT HOUSES | 'SLOPE-DOOR HOUSES'

South-east Finland is the heart of the Finnish wood-processing industry, with its many factories, as well as residential areas linked with them. Already from the mid-1930s onwards Aalto was involved in designing the Sunila pulp mill area at the mouth of the Kymi River near Kotka. The factory was located on a shoreline with a rocky terrain and pine forests typical of the Gulf of Finland. The Sunila factory itself was placed on an island, while the fan-shaped residential area, which freely follows the form of the terrain, was placed on a south-facing slope on the adjacent mainland. The building groups were laid out hierarchically, from manager and engineers to the foremen and workers. Different types of multistorey and terraced houses were spread in loose clusters around the site. The residential area in Sunila was the first Finnish so-called "forest town", and one of the few built examples in Finland of the German *Siedlung* principle. The residential area was built slowly in stages from the 1930s to the 1950s, which enabled a 'continuity in the experiment'.

The most notable housing type experiment in Sunila was the ROT ("rinne-ovi talo" = slope-door house) houses built by the EKA housing company for the working population. They are type-plan houses, and were intended to be built more widely both in Sunila as well as in other nearby large factory areas. Their plan solutions, which were simultaneously compact yet included balconies and terraces, were Aalto's answer to the housing problem.

The ROT houses were a variation of the stairless apartment block but with the character of terraced housing. The experiment was made possible by the steep slope in the north part of the area, in the immediate vicinity of the entry access road. Each of the apartments in the three-storey blocks has a direct connection to ground level. The apartments on the first two storeys have their own private entrance and only the top floor apartments are accessed via stairs.

∧ The rear side of the building, as seen from the upper slope.

< The external space of each individual ground floor apartment is differentiated from the surroundings by low, raised terraces.

The minimum-sized apartment utilised every corner: for instance, the washbasin was placed in the 'corridor recess'. Each function in the apartment had its own allotted 'corner'.

The 39m² apartments, containing a kitchen, 'sleeping alcove' and living room, were regarded as the minimum size possible. The apartments, placed one above the other, have different floor plans. Despite the small size of the apartments, they appear spacious, and in each one of them the internal space extends out to the exterior through large west-facing windows. Every apartment has its own outdoor space: a yard, a terrace the depth of the apartment, or a balcony. Aalto himself thought the size of the balconies would be sufficient for "practical outdoor life".

The exterior of the houses with their white rendered walls represents so-called White Functionalism and International Style Modernism. The dark wooden balcony rails, however, soften the overall appearance. The projecting transverse walls between the apartments create a rhythm to the long building volumes.

The terrace of the first-floor apartment enlarges it both visually and functionally.

1

2

3

40

<< Floor plans 1:250.

<< Site plan. The group of houses built by
v the EKA housing company includes,
 in addition to the ROT houses, three
 three-storey lamellar houses set into
 the slope as well as a heating plant
 building. 1:1500

< The cross-section shows the
 relationship of the apartments on
 three levels to the ground level. The
 storage spaces ['komerot'], marked
 on the drawing both below and above
 the stairs, show the efficiency-thinking
 behind the planning of the minimum
 apartment. 1:200

v A view of the ROT houses after
 their completion. The texture of the
 brickwork clearly shows through the
 thin brushed render.

Kauttua, Finland, 1937–1938

STANDARD TERRACE HOUSING

The Kauttua industrial area and community is situated in a beautiful natural landscape in western Finland. In 1937–38 Aalto designed several master plans and building plan proposals for the area. The ideal was to create a stage for both new architecture and a new modern way of life.[1] The starting point for the master plan was to place the housing areas amidst the ridge landscape, which was seen both to have natural beauty and to promote health. Aalto emphasised that in a country like Finland only the best terrain should be selected for residential areas, for they contained both biological and psychological benefits.[2] The extensive plan proposal, which included high-rise, terraced and stepped terrace housing, was situated on a slope somewhat like a hill town, at the highest point of the whole area and with open views in all directions. The idea was to build housing only on those slopes which were most favourable with regards to orientation.

The topographical characteristics of the site gave the starting point for the design of the buildings, the principle of a stairless apartment block. The steep slope enabled the building of stepped buildings, so that each storey had a direct connection to the terrain. Aalto's aim was to build even seven-storey buildings with this principle. The plan, however, was reduced to a group of four stepped terraced houses, of which only one was actually built.

Aalto justified his design solution on many levels; for instance, by leaving out stairs the net floor area was increased, and the apartments could open out in as many as three directions. The form of the apartment was thus more favourable than in a normal multistorey building and freer than in a terraced house.

For Aalto the Kauttua stepped terrace house was also meant to be a standard house type to be built in other locations. Also, the building showed the desire of the management of the client-developer, A. Ahlström, to solve the housing issue of their industrial plants in a new way.

The stepped terraced house built in Kauttua has four storeys. The apartments are laid out such that the terrace of each apartment lies partly on the roof of the one below it. Each apartment has a separate entrance directly from ground level. The building is comprised of three fairly large apartments on the lowest levels and three smaller ones on the upper level. The rooms are grouped around the living room, which forms the heart of the apartment. Within the 'dark' spaces dug into the slope were placed storage and service spaces. The extensive terraces are a central part of the building with regards to both the external architecture and internal spaces. They extend the apartment out into the exterior and offer a view into the surrounding landscape. The rails and pergolas of the terraces were made from un-barked poles, which was Aalto's way of binding together a man-made building and nature, while the white-rendered basic shape of the building forms a clear contrast to its surroundings. Aalto placed the building sensitively in the terrain and landscape: the terraced paths with their natural stone walls and the rhythmic stepping of the building demarcate the surroundings otherwise untouched by man. Nature and humane building come together.

1 Pekka Korvenmaa, *Kauttua. Tuotanto ja ympäristö 1689–1989.* A. Ahlström, Uusikaupunki 1989, p. 89.
2 *Arkkitehti*, 12/1939, 161–163.

The large apartments open up in three directions and optimally attain the atmosphere of a detached house. The view of the pine forest is an essential part of the interior spaces. The system of ventilation intakes situated below each window is similar to that used in the Aaltos' own house in Helsinki.

The terrace, which is the width of the whole apartment, gives a Mediterranean-like element to the Finnish lifestyle and landscape.

The original site plan 1:2000, with the group of four stepped terraced houses fitted into the slope. The network of paths follows the height lines and the terrain.

∧ The first floor plan. In addition to the 'front entrance', the apartment has a connection to the 'back yard'. 1:200

∨ Terraced house at the end of the 1930s.

Cambridge, USA, 1946–1949

BAKER HOUSE | SENIOR DORMITORY, MASSACHUSETTS INSTITUTE OF TECHNOLOGY

MIT is situated along the Charles River facing the City of Boston. Aalto was a professor at MIT during the 1940s and in 1946 he was commissioned to design the senior dormitory. A long narrow site had been reserved for the building along the river, as part of the university's 'river front', albeit that there was a busy road between the site and the river. The starting points for the form of the building were closely related to the site location and room programme. The American orthogonal grid town plan and the ruler-straight river were in Aalto's view a highly inhumane combination that had to be broken. He finally arrived at a six-storey building with a curved wall towards the river, the benefit of which was the possibility of opening up a view from the majority of the rooms towards both the river and the south, the most favourable orientation. At the same time he could minimise the disadvantages, such as the noise coming from the busy road. Aalto justified the form of the building by presenting a comparative study showing the pros and cons of a number volumes organised and grouped in different ways. The central problem was to fit into the building the number of rooms required by the client. In the end only a small number of the rooms had to be placed on the north side of the building.

The building's internal circulation was concentrated in the 'cascading' stairs cantilevered from the north side, and via which one ascends to the main corridor

on each floor level. Aalto organised the spaces "democratically", for instance in the sense that the lounges were made increasingly spacious the higher and further away they were from the entrance and main lobby.

Red brick was the dominant building material. Aalto himself described the use of brick as follows: "All bricks were approved without sorting, with the result that the colour shifts from black to canary yellow, though the predominant shade is bright red."[1] For the external walls an extremely coarse brick was chosen, fired to give it an uneven and lively character. Internally, as used in the dividing walls between the rooms, the red brick creates, in combination with the wooden furniture, a cosy atmosphere.

The human aspect of the large brick building was expressed through the use of unevenly fired bricks; their colour and form vary, creating a living surface.

The whole building can be seen as an interpretation of a 'hill town', the public and private spaces of which have been organised hierarchically. The ground floor entrance hall, with its common spaces, is linked to the separate low cafeteria and refectory pavilion. The pavilion differs from the rest of the building, with regards to both its rectangular form and its material, a light grey marble. The latter, with its large windows and expanse of cylindrical roof lights – a favoured Aalto device – can be seen as forming the square of a miniature town, while the corridors leading to the student rooms are the residential streets, along which small local common spaces open up. The spaces are clearly differentiated – from public to private via semi-public. A balance between individual peace and free social interaction is attained.

< The main entrance.

∧ Variations of stairs is a central theme in Aalto's architecture. In the MIT senior dormitory the 'cascades' of the stairs bring the whole building together. The stairs dominate the rear façade, which in its angularity forms a counterpart to the curving façade on the river side.

< A large fireplace forms a focal point in the ground floor lounge.

v In the refectory pavilion Aalto used cylindrical roof lights similar to those he had used earlier in the Viipuri Library. The pavilion opens out towards the river through a facade of horizontal windows. The two-level space resembles the floor plan solution typical for many of Aalto's libraries.

MIT SENIORS' DORMITORY ROOM PLANS GROUP 'C'

The furnishing principle in the one- and two-person rooms illustrates the overall clarity of the functional organisation. Each room is unique in both appearance and form. 1:200

Aalto made comparisons with nature in presenting his design. He compared the varying depth of the body of the building to a pine branch, at the end of which the needles and smaller branches are grouped more closely. Likewise, the stairs, corridors and social spaces were for him a 'mixed forest', simultaneously living and uniform.[2]

The size of the student rooms varies from small single-person rooms to three-person rooms. The smallest rooms are situated on the curved parts of the building. The wedge-like shape of these rooms is the earliest built example of a fan-shaped dwelling solution, which Aalto subsequently used, for instance, in the Neue Vahr housing in Bremen, Germany. Its position along the curved form, however, gives each room its individual appearance. The stepped line of the dividing walls between the rooms divides the space in each room into 'places' – for sleeping, working and washing – with a separate space for each function even in the smallest rooms. An essential part of Aino Aalto's integrated interior design was the emphasis given to the emergence of natural corners for different functions furnished with the Aaltos' Artek-produced furniture.

1 *Arkkitehti* 4/1950, 54.
2 Ibid, 53.

MIT SENIOR DORMITORY
FIRST FLOOR PLAN

MIT SENIOR'S DORMITORY
SECTION THROUGH DINING HALL - MAIN LOUNGE - ENTRY

M.I.T. SENIOR DORMITORY

< Ground floor plan 1:700.

< A cross-section through the entrance
v lobby and the refectory pavilion.

v A view of one of the rooms soon after the completion of the building. The rooms were frugal yet carefully designed down to the details. The interior walls of the rooms are also in red brick. Aalto gave the following guideline to the architects in his office: "Not quaint; there should be 'raw details'" (Veli Paatela, cited in Louna Lahti: *Ex intimo. Alvar Aalto through the eyes of family, friends and colleagues.* Building Information Ltd: Helsinki 2001, pp. 112–113).

Helsinki, Finland, 1952–54

NATIONAL PENSIONS INSTITUTE EMPLOYEE HOUSING

The National Pensions Institute employee housing is situated in Munkkiniemi, in the west part of Helsinki. The Aaltos' own house, completed in the 1930s, is located in the same district. In 1949 Aalto had won the competition for the National Pensions Institute offices, the construction of which, however, was delayed. On the basis of this work Aalto was commissioned to design the Institute's staff housing, for which a separate site had been reserved. Aalto recalled that the mosaic-like nature of the site had been a difficult starting-point.[1]

The four five-storey blocks were placed on the site where possible following the street lines, so that the green spaces between them would be as large as possible. In the 'hinge' between the buildings is a small square, a piazza, elevated slightly higher than the surrounding street level. Part of the ground floor of one of the buildings had originally been reserved for commercial spaces. The two arcades facing each other across the square emphasise its public character. The juxtaposition of the lamella houses, which were in themselves rather simple, in relation to the layout of their volumes creates nuanced urban and courtyard spaces. The mosaic-like nature of the site has indeed been converted into a positive feature. With such material Aalto created visually a small town. He himself characterised the housing block as three-dimensional: its character changes when approached from different directions.[2]

The dwelling solution is based on lamella blocks in which there are usually two two-roomed apartments and one one-roomed apartment around each stairwell. The largest apartments were placed in the block at the corner of the piazza. The plans of the apartments were rather ordinary, but each room had its own character due to the variety in the fenestration composition. The balconies were the width of the whole apartment. Light-toned red brick is the dominant building material. The change in the type of brick bonding in the attic floors of the facades creates a differentiation in the volumes of the buildings. The balcony parapets are white concrete prefabricated elements. The brick cross walls dividing the apartments help to accentuate their horizontality.

1,2 *Arkkitehti*, 3/1957, 33.

The city block has many faces: in places it is outwardly wall-like, brick is the dominant material in the animated street façade, while the building is more open and with a horizontal character on the courtyard side.

∧ A view of one of the stairs.

< The yard side of the southern-most block: the ground floor apartments have their own small yard area. The transverse walls, reminiscent of those used in the Sunila ROT houses, give a rhythm to the balconies.

∧ Even though Aalto had stated that the occupants should not furnish their homes with his furniture only, it is nevertheless marvellous to see the warm and timeless atmosphere created by the use of his furniture, lamps and glassware from different periods. The 'Beehive' lamp hangs above the fan-legged coffee table. The shallow glass vases were designed in the 1930s; one was part of the "Eskimo woman's leather breeches" series, which won the Karhula-Iittala glass design competition in 1936.

< The lamp above the dining table was designed by Aalto for use in the National Pensions Institute building.

∧ From the living room there is a direct access to the balcony, which is the width of the whole room. The garden table was designed originally for Villa Mairea.

< The armchair is a model Aalto designed in the beginning of the 1930s. The small table was designed originally for the Paimio Sanatorium.

v The floor plan of the lamellar housing block 1:350.

v The site plan illustrates how the lamellar blocks, which in themselves are rather simple, form an interesting whole. A kindergarten was planned for the courtyard, but was never built. 1:1500

v The facade of the block (1:400) facing the small 'piazza'. The attic floor of the building was differentiated from the rest through the use of a different brick bonding and by pulling in the façade.

v A view of the 'piazza' soon after the completion of the project.

Berlin, Germany, 1954–1957

HANSAVIERTEL APARTMENT BUILDING

The intention behind the Interbau Berlin 1957 exhibition was to build a new (perhaps even a future) city district in an area north of Tiergarten that had been completely destroyed in the war. Internationally renowned architects such as Oscar Niemeyer, Walter Gropius and Arne Jacobsen were invited along with German experts to plan the Hansaviertel area. Aalto had been invited to take part in the exhibition in 1954. The area was to contain mainly apartment blocks but also to some extent terraced houses. Aalto made designs for several sites and the final "Haus 16" was located in the heart of the area, next to the underground station.

In the Hansaviertel building it is as if two point blocks have been joined together. Each of the light and spacious stair landings of the eight-storey building gives access to five apartments. One of the objectives in the floor plan solution was to obtain as many apartments as possible oriented towards the west and south-west. Aalto made variations on a basic type floor plan solution from the Hansaviertel building in the unrealised plans from 1959 for housing areas in Karhusaari and Hanasaari in Espoo.

The entrances to the building are on two levels. The open 'hall of columns' on the upper level forms a square between the two tower sections. This free-flowing space was designed to function as a covered outdoor space, and it has direct access to the courtyard area. Originally a black and dark blue free-form pattern was painted on the ceiling.

Aalto differentiated the stairwells though the placement of colour on the floor: the actual walkway as well as the steps are in black terrazzo and the areas next to the entrances as well as the risers in the stairs are in white terrazzo. The facades of the building are built in light-coloured concrete slabs.

The hall of columns, at one of the entrance levels, forms an open space in the core of the building. There is also access to the stairwells via a lower level. The stairs, which offer views out, have an important position in the building. Particularly the stairs with corner windows is almost like a room in itself.

The rhythm of the balconies is
emphasized in the courtyard facade.
They stretch towards the light and the
green courtyard.

There are all in all 100 apartments in the building, the largest of which are 83–90 m² and the smallest 35 m². Most of the apartments are large. It was in the design of the apartments of the Hansaviertel building that Aalto created the idea of a central hall in its purest form: this had been an ideal of his since the 1920s. The hall-cum-living room is the heart of the apartment, around which the other rooms gather. Furthermore, this room continues as a deep and sheltered balcony accessed also from both the kitchen and bedroom. The balcony becomes one of the rooms. A wooden grid-form screen and door demarcates the living room from the kitchen. The spatial uniqueness of the central room, equivalent to the central living space, the so-called 'tupa', in a traditional Finnish farmhouse, is emphasised in the floor tiles which differ in colour from those in the rest of the apartment.

∧ The exhibition apartment was
< furnished with Artek furniture
 imported from Finland.

>∧ The entrance floor plan. The floor
 plan of the 'atrium apartments'
 partly resembles Alvar Aalto's own
 summer house, the Muuratsalo
 experimental house. 1:500

> The hall of columns in its original
 state, with an organic pattern
 painted on the ceiling. The space
 can be seen as referring to a forest
 and a lake.

Avesta, Sweden, 1955–1961

HOUSING AND BUSINESS COMPLEX, SUNDH CENTRE

Aalto made two notable designs for the small town of Avesta in Sweden in the 1940s: the Johnson Institute as well as a plan for the town centre, neither of which were realised. However, the connection with Avesta remained through engineer and businessman Ernst Sundh, who was a shareholder in Artek's factory in Sweden. In the mid-1950s Sundh commissioned a plan from Aalto for a residential and commercial building, to be built on a triangular-shaped site. The triangular-shaped complex is dominated by an eight-storey tower block with a steep mono-pitched roof.

The other two wings are three storeys. The commercial and office spaces are located on the ground floor. The apartments in the complex consist mainly of three rooms plus a kitchen and they are grouped in two different ways: in the low wings in lamellas and in the tower block densely around a central stairwell. Unusually, none of the apartments have balconies. Sundh's own apartment was placed on the top two floors of the tower block. The most distinctive feature of the building is its façade material, dark blue vitrified tiles.

∧ A stairs in one of the lamella wings.

< The street facades are finished
 in a dark blue vitrified tile.

> The one-room apartment on the first floor is among the smallest in the building.

v The north façade 1:600.

\>\> First and second floor plans 1:600.

\>\>
v A view of the building soon after its completion.

99

Rovaniemi, Finland 1956–1960 (Rakovalkea block 1958–1959, Poroelo block 1960)

KORKALOVAARA APARTMENT BUILDINGS

The town of Rovaniemi was almost completely destroyed in the latter stages of the Second World War. The rebuilding, which Aalto participated in as the head of the Finnish Association of Architects' Office for Reconstruction, began with the design of a new town plan. Aalto saw the work as a model where society was looked at analytically, starting from its economic and traffic structure and extending all the way to individual buildings. The result was the so-called "Reindeer Horn" plan, with its spaciously built open blocks.

The Korkalovaara housing district was built in the 1950s when there was still a severe housing shortage in Rovaniemi. The Tapiola garden city, which was under construction in the mid-1950s, became the model for regional housing developments. The Housing Foundation, which was the builder-developer behind Tapiola, also carried out the Korkalovaara area in cooperation with the town of Rovaniemi. A variety of apartment blocks as well as terraced and chain houses were placed in the garden-like plan. They were built with the help of the Arava state-subsidised loan system. The buildings were placed along the street lines, which in turn were arranged in a fan-shaped formation. As much as possible the apartments were oriented southwards to maximise access to sunlight at a latitude with a long sunless period during the winter. Families were to be housed in terraced and single-family houses. Also a shopping centre with a public square, together with a district heating plant, formed part of the whole.[1]

1 Päivi Lukkarinen (Ed.), *Aalto in Lapland*. Rovaniemi Art Museum, Rovaniemi, 1998.

There is a direct connection from the ground floor apartments out into the courtyard. The original 'balcony' idea for the Korkalovaara blocks is also reflected in the façade fenestration: behind the lower part of the L-shaped window there was originally a semi-heated space – a kind of conservatory – separated by glass walls from the living area. Aalto used the L-shaped window for the first time already at the end of the 1920s, in his competition proposal for the patient rooms in the Paimio Sanatorium.

The fan motif is repeated not only in the placement of the buildings but also in the floor plan solutions of the Rakovalkea and Poroelo blocks. Small one- and two-room apartments were placed in these two four-storey blocks: the larger in the lamella sections and the smaller in their fan-shaped ends. There was a direct connection from the ground floor apartments into the park-like yard, into nature. As a special feature, Rakovalkea had 'semi-balconies' which were unheated spaces built within the building frame and linked via glazed walls to the living room. Instead of the communal sauna, that had been planned as a 'hinge' point between the two blocks, a bicycle and storage shed was built. The external facades are given a pleasant rhythm due to the fan-shaped plan, as well as by the stepped or L-shaped windows, typical also for some of Aalto's other multi-storey buildings. The facades are mainly of brick and have been given a thin rendered finish.

< The original 'semi-balcony'. Nowadays the majority of the semi-heated spaces of the apartments are connected to the living areas.

v Site plan. The overall plan included apartment blocks and terraced and detached houses, of which only a part was built. A small shop was built as 'gateway' building to the area. 1:2000

\> A typical floor plan in the Rakovalkea housing block. 1:600

\>
v A view of the courtyard in about 1960. Fences mark off small yards for the ground floor apartments.

ROVANIEMI
KORKALORINNE 1/500

ROVANIEMI, KORKALORINNE

Bremen, Germany 1958–1962

NEUE VAHR APARTMENT BUILDING

In the 1950s and 1960s a new large city district was built in the north part of Bremen, Neue Vahr. The Gemeinnützige Wohnungsbaugesellschaft (GEWOBA) commissioned Aalto to design a landmark for the area. The tall tower block designed by Aalto was to be located next to the commercial centre and park area.

The 22-storey building consists only of small apartments, of one and two rooms, all wedge-shaped, collected together in a fan oriented westwards. In this building Aalto realised a design principle he had been considering at the time, according to which couples without children and single people could live in high-rise buildings.

The proximity of the commercial centre ties the building intimately to the urban space via a small square. The ground floor was reserved for offices. Views of Bremen open up from the top floor roof terrace. The façades are made from prefabricated concrete elements. The shape of the building is skilfully composed, with a rhythm created by the windows, balcony recesses, and wall slabs. The stylish material of the entrance vestibule – red floor-tiles, thin blue vitrified wall-tiles and the warm-toned varnished wooden battened ceiling – create quite a luxurious feeling.

The Neue Vahr apartment building is adjacent to a local shopping centre. Originally, at the end of the 1950s, the commercial spaces were in a low building situated along one side of the square. Since then more buildings have been erected around the square.

The entrance lobby overlooks the pedestrian precinct. The lobby is a kind of central square for the building, with carefully finished materials and details: a tiled floor, tile-covered pillars and walls, as well as a wooden ceiling create a warm atmosphere.

Detail of the free-form battened suspended ceiling.

The ideal of communality was followed on each floor of the building by means of a light street-like corridor that also extends into a common space overlooking the surrounding landscape. The free-form battened suspended ceiling in the latter space emphasises its public character. A painted wooden partition further divides the space from the corridor. Unfortunately, fire-safety regulations have prevented the vestibules from being used as originally intended. The entrances to the apartments are set in small recesses that create a sort of semi-private front – suggesting that the interior space begins already outside the door of the apartment.

Each floor landing serves nine apartments, all of which differ from each other. The entrance hall, bathroom and kitchen are placed at the narrow stairwell end of the deep apartment, while the living room opens out to the views. A glass partition between the kitchen and the living room gives feeling of spaciousness to the small apartment. Each apartment has its own balcony, its own external space.

∧ Light penetrates through to the access corridors on each of the floors. The space at the end of the corridor was originally designed to be a lounge-like common space.

< A view of the interior of a typical fan-shaped apartment, towards the balcony.

> Typical floor plan. 1:250

HOCHHAUS, BREMEN
NORMALGESCHOSS 1/50 HELSINKI 6/8/58 ALVAR AALTO

< A perspective view from the square.

>∧ The site plan, showing the tower block and shopping centre. The tower block is the focal point of the square. It also dominates the Neue Vahr district: this is particularly apparent when viewed from the adjacent bypass, as well as from across the artificial lake.

Tapiola, Espoo, Finland, 1961–1967

HARJUVIITA APARTMENT BUILDINGS

The construction of the Tapiola Garden City began in the early 1950s. The main planning principle was to bring together nature and building. The seven point blocks situated east of Otsonlahti Bay designed by Aalto are part of the 1960's building stage. The buildings are situated on the summit of a rocky ridge and are an important part of the overall landscape and silhouette. The buildings are grouped in two spacious clusters.

Aalto had developed a similar tower block design already in the 1940s: the principle behind the Tapiola blocks was indeed a development of the building type of the Heimdal residential area in Nynäshamn, Sweden. At that time, at the end of the 1940s, Aalto gave thought to the 'justification' for building tall tower blocks. Even though he rather reluctantly accepted building high, as a realist he stated that it was not possible to solve the problem of building communities by using only the ideal solution of building low. He sought justification for tall multistorey buildings from the circumstances of the landscape and nature, as well as the from the structure of society. The architect's responsibility was to offer in a tall building more spacious dwellings and faultless orientation with regards to light and views. According to Aalto, the architectonic demands of tall multistorey buildings, as well as the artistic and social responsibility of the architect, were greater than those of low buildings.[1]

These requirements were fulfilled in the Harjuviita houses. The apartments are oriented towards the light and sea views. They sit naturally in the terrain, which is still to a large extent in its natural state. Deep atrium-like balconies become the inhabitants' private external spaces. The seven-storey brick-faced buildings were painted in a light tone. Even though the buildings were built in different stages, and partly even by different builders, they still form a uniform group.

[1] Alvar Aalto, "The Housing Problem" in Göran Schildt (Ed.) *Alvar Aalto in His Own Words*. Otava, Helsinki, 1997 [original, *Arkkitehti* 7–8/ 1946, 83–85].

The point blocks, situated in two groups along the shore of Otsolahti bay, rise above the level of the tree tops. The virgin rocky terrain between the buildings was left untouched. According to the general principles in the planning of the Tapiola Garden City, the plot boundaries are not clearly demarcated and nature comes right up to the buildings.

The entrance and stairwell to one
of the point blocks.

130

<< The site plan of the Harjuviita area. The groups of fan-shaped buildings were placed on the summits of the rocky outcrops, and the lamellar and terraced houses lower on the slope.

<< The south façade 1:300.
v

< A view of the kitchen.

v A typical upper floor plan 1:300.

Otaniemi, Espoo, Finland 1963–1966

STUDENT HOUSING | HELSINKI UNIVERSITY OF TECHNOLOGY

A competition for the design of the university campus was arranged in 1949. Aino and Alvar Aalto's winning proposal for a standard residential building type for the student village situated on a forested cape consisted of three point blocks linked by corridors. This building type was indeed implemented in the 1950s, not by the Aaltos but by Heikki Siren and Martti Melakari, architects of a younger generation. In 1962 Aalto made a new plan for a four-storey student dormitory, a unit of cells linked together, a kind of combination of the curved wall of the MIT dormitory and the fan-volume of the Neue Vahr block. The plan was carried out in a reduced and adapted form, and remained the only residential building designed by Aalto in Otaniemi. The volume of the so-called TKY 2 student dormitory is V-shaped and tripartite, that is, with two straight wings linked by a curved wall-like central section.

The form of the collective housing is in this case simple: in the straight wings the rooms are gathered along a central corridor, and the common spaces open up directly into the corridor; in the curved parts the street-like side corridor expands naturally to form common spaces. Each cell group has its own stair-well. Communality and privacy meet sensitively also in this building. The low vestibule space, lit by cylindrical roof-lights, is situated at the joint of the two wings. The facade material is red brick and follows the general principle for building materials on the Otaniemi campus.

The student village is situated amidst
nature on a forest cape.

∧ The shape of the central stairwell follows the general direction of the fan-shaped section of the building.

< The typical Aalto theme of a grid of cylindrical rooflights has been used in lighting the lower hall.

< A typical student room.

v Floor plan, 3rd and 4th floor. Connected to each common room is a balcony. 1:500

> The west facade. The recessed balconies break up the even rhythm of the façade created by the L-shaped windows. 1:500

TKY 2 OTANIEMI JULKISIVU LÄNTEEN 1/100

Lucerne, Switzerland, 1964–1967

SCHÖNBÜHL APARTMENT BUILDING

Aalto had got to know Swiss architect Alfred Roth already at the end of the 1920s. It was through Roth that Aalto received the commission to design the 16-storey tower block for a private developer in Lucerne. The building is closely linked with the shopping centre which Roth himself designed. The building is situated south of the city centre, near the lakeside and with a magnificent alpine landscape as a backdrop. In designing the building it was indeed important to orientate the apartments towards the lake and mountain view in the south east. Aalto also designed a restaurant for the ground floor.

The fan-shaped plan solution of the Schönbühl tower block is based on the Neue Vahr building in Bremen. There are, however, more apartment types here, from one room plus a kitchen to six rooms plus a kitchen. The apartment on the roof level is like a private house on top of the building. The main entrance vestibule of the building stretches the whole depth of the building. The corridors on each floor are spacious and light. They can be interpreted as a public street-like space. Central features of the spatial solutions of the apartments are the fan shape, with the help of which the apartments reach towards the light, and the characteristic balcony as a private external space.

The facades of the building are made from prefabricated concrete elements. Despite the industrial material, the building has a strong sculptural appearance. An angular broken line was created by the placement of different-sized apartments. Aalto also wanted to show that a prefabricated element building can be a 'biologically-shaped house'. Between 1968 and 1972 Aalto made plans for additional buildings, which included both multistorey as well as terraced houses and a lakeside restaurant, but these were never built according to his plans.

The point bock landmark dominates its surroundings. The low shopping centre is closely connected to it. Due to the fragmented line of the facades and fan-shaped plan, the appearance of the building changes as one approaches it from different directions.

∧ The tall and spacious entrance hall opens up towards the courtyard and the shopping centre. The corridors on each floor level are characterised by light and transparency.

> The top-floor apartment can be seen as an individually designed 'detached house'. The entrance hall is lit by rooflights.

>> The library, living room and dining area form a continuous flowing space. There is a stunning view from the apartments towards the mountains and lake.

The kitchen and auxiliary spaces are lit by cylindrical rooflights typical of Aalto. An extensive roof terrace runs along the outside of the top-floor apartment.

152

<< A perspective of the courtyard side of the building. Prefabricated concrete elements were used for the exterior walls.

<< Floor plan of a typical floor. The smallest apartments have been grouped in the centre and the largest ones at the ends of the fan. 1:300
v

< Site plan. In addition to the point block, Aalto's scheme included terraced houses and a lakeside restaurant, but the latter were never built.

v Floor plan of the top-floor apartment 1:300.

Alvar Aalto in Munkkiniemi,
Helsinki in 1956.

HUGO ALVAR HENRIK AALTO

1898	born at Kuortane on February 3rd
1916	matriculated from Jyväskylä Lyceum
1921	diploma in architecture from the Institute of Technology, Helsinki
1923–27	private architectural office in Jyväskylä
1924	married to architect Aino Marsio (died in 1949)
1927–33	private architectural office in Turku
1933–	private architectural office in Helsinki
1943–58	Chairman of the Finnish Association of Architects
1946–48	Professor at Massachusetts Institute of Technology (Cambridge, USA)
1952	married to architect Elissa (Elsa Kaisa) Mäkiniemi
1955–	Member of the Finnish Academy
1963–68	President of the Finnish Academy
1976	died in Helsinki on May 11th

SELECTED WORKS

- House and sauna for Terho Manner, Töysä, Finland 1923.
- Municipal hospital, Alajärvi, Finland 1924–28. **1**
- Railway Workers' Building (Aira Apartment Building), Jyväskylä, Finland 1924–26.
- Workers' Club, Jyväskylä, Finland 1924–25. **2**
- Vekara summer villa, Karstula, Finland 1924.
- Defence Corps Building, Seinäjoki, Finland 1924–26. **3**
- Atrium house for Väinö Aalto, Alajärvi, Finland. Project 1925.
- Casa Lauren, Jyväskylä, Finland 1925–28.
- Villa Flora, Alvar and Aino Aalto's summer residence, Alajärvi, Finland 1926. Extended 1938.
- Väinölä, residential building designed and built for Väinö Aalto, Alajärvi, Finland 1926.
- Muurame Church, Finland 1926–29. **4**
- Defence Corps Building, Jyväskylä, Finland 1926–29.
- Southwestern Finland Agricultural Cooperative Building, Turku, Finland 1927–28.
- Standard apartment building (the Tapani Building) Turku, Finland 1927–29.
- Viipuri library (Vyborg, now in Russia), competition 1927. New drawings 1928, 1929 and 1933. Built 1934–35, according to the 1933 design. **5**
- Aitta magazine, summer and weekend cottage competition 1928.
- Tuberculosis Sanatorium, Paimio, Finland, competition 1928–29. Built 1930–32. Housing 1930–33, 1960. **6**
- Office building for Turun Sanomat newspaper, Turku, Finland 1928–30.
- Turku 700th anniversary exhibition. In close collaboration with Erik Bryggman, Turku, Finland 1929. Demolished.
- Minimum Apartment Exhibition, Helsinki, Finland 1930. Demolished.
- Toppila company, pulp plant, Oulu, Finland 1930–33.
- Villa Tammekann, Tartu, Estonia 1932.
- The Stenius residential area, Helsinki, Finland. Project 1934–38
- The Aalto House, Alvar Aalto's own house and office, Helsinki, Finland 1935–36.
- Savoy Restaurant interior, Helsinki, Finland 1936–37.
- Sunila company, sulphate pulp mill and factory housing area. Kotka, Finland 1936–39, 1945–47, 1951–54.
- The Finnish Pavilion, Paris World Fair 1937, Paris, France 1936–37. Demolished.
- A. Ahlström company, prefabricated type houses 1937, 1939–41. AA houses were built in several locations.
- Inkeroinen master plan, Anjalankoski, Finland 1937, 1940s.
- Tampella company, Anjala paper mill and housing, Anjalankoski, Finland 1937–38, 1942–56.
- Kauttua master plan and stepped terrace house, Eura, Finland 1937–38.
- A. Ahlström company, Kauttua factory and residential building, Kauttua, Finland 1937–1940s.
- Otsola residential area, Kotka, Karhula, Finland 1937–38, 1941–42.
- Art Museum, invited competition entry, Tallinn, Estonia 1937.
- Inkeroinen primary school and teachers' housing, Anjalankoski, Finland 1938–39.
- The Finnish Pavilion, New York World Fair 1939, New York, USA 1938–39. Demolished.
- Villa Mairea, Noormarkku, Finland 1938–39

- 'An American town in Finland' – experimental town. Theoretical project 1940.

- HAKA housing competition, Helsinki, Finland 1940.

- Housing for ex-servicemen, Tampere, Finland 1940–41, 1943.

- Logging camp, bunk-house 1940. Built in several places as emergency accommodation.

- Kokemäenjoki valley, Finland. Regional plan 1941–42.

- Town plan for Könönpelto residential area, Varkaus, Finland 1941–44.

- A. Ahlström company, housing, Kotka, Karhula, Finland 1942–48. Warehouse for Karhula glassworks, extension 1949–57.

- Town plan, Säynätsalo, Finland 1942–66.

- Finn-house system. Prefabricated houses for export. Prototypes built 1943–45.

- Atri company, housing, Kittilä, Finland 1943–46.

- Johnson Institute and Avesta central area plan, in collaboration with Albin Stark, Avesta, Sweden. Project 1944.

- 'Reindeer antler' master plan, in collaboration with Viljo Revell and Yrjö Lindegren, Rovaniemi, Finland 1944, continued in 1950s.

- Strömberg company, factory and housing, Vaasa, Finland 1944–48.

- 'Skatan' terraced housing block. In collaboration with Albin Stark, Avesta, Sweden. Project 1945.

- Standard type-houses for Tampella company's forestry department staff 1945. Built in various locations.

- Tampella company, Pekola housing area, Tampere, Finland 1945–52.

- Yhteissisu company, housing, Hämeenlinna, Finland 1945–46.

- Heimdal housing area, in collaboration with Albin Stark. Built according to Stark's design, Nynäshamn, Sweden 1946–48.

- Massachusetts Institute of Technology. Senior Dormitory (Baker House), Cambridge, USA 1946–49.

- 'Metsäkaupunki' master plan, partly implemented, Imatra, Finland 1947–57.

- Interior design for 'Poetry Room' at Harward University, Cambridge, USA 1948.

- Strömberg company, Pitäjänmäki housing and offices, Helsinki, Finland, 1948–49.

- Finnish Engineers' Association Building, Helsinki, Finland 1948–53.

- Otaniemi master plan competition, partly implemented Espoo, Finland 1949–74. Buildings by Aalto include: sports hall 1949–52, Main building 1953–64 with extensions 1976–78, laboratories, heating plant, student housing TKY 2 1963–66, library 1964–70, water tower, shopping centre and bank. Buildings for Technical Research Centre of Finland, laboratories 1955–1960s. **7**

- Enso-Gutzeit company. Standard houses 1949–57. Built in various localities.

- Säynätsalo town hall, Jyväskylä, Finland 1949–52. **8**

- Typpi company, factory and housing area, Oulu, Finland, 1950–53, 1954–56, 1958–63, mid-1960s.

- Enso-Gutzeit company, Kallvik country club and sauna, Helsinki, Finland 1951–52. **9**

- Rautatalo, Helsinki, Finland 1951–55.

- Institute of Pedagogics (Jyväskylä University), invited competition, Jyväskylä, Finland 1951–71. Buildings include: Teaching practice school, gymnasium, student hostel, cafeterias, main building 1954–1955, swimming hall, student union building, building for the Faculty of Sport and Health Sciences 1951–71. **10**

- Church, Seinäjoki, Finland. Competition 1951. Built 1958–62.
- Enso-Gutzeit company, Summa paper mill, Vehkalahti, Finland 1951–58. Summa housing area, Vehkalahti, Finland 1956–61.
- House of Culture, Helsinki, Finland 1952–58. **11**
- Housing for the National Pensions Institute, Helsinki, Finland 1952–54.
- Muuratsalo experimental house (Aalto's own summer villa), Jyväskylä, Finland 1952–53.
- Aero company, housing, Vantaa, Finland 1952.
- National Pensions Institute, Helsinki, Finland (1948) 1953–57.
- Sauna for the Muuratsalo experimental house, Jyväskylä, Finland 1953–54.
- Studio Aalto, Helsinki, Finland 1954–55, extended 1962–63.
- Sundh Centre, Avesta, Sweden 1955–61.
- Hansaviertel apartment building, Berlin, Germany 1954–57.
- Vuoksenniska church (Church of the Three Crosses), Imatra, Finland 1955–58. **12**
- Finnish pavilion for the 1956 Biennale, Venice, Italy 1955–56.
- Maison Carré, Bazoches sur Guyonne, France 1956–59, 1961.
- Pirttikoski standard housing area, Rovaniemi rural district, Finland 1956.
- Korkalovaara apartment buildings, Rovaniemi, Finland 1956–60.
- Parish centre, Seinäjoki, Finland 1956.
- Museum of Central Finland, Jyväskylä, Finland 1957–62, 1991.
- Viitaniemi garden city, in collaboration with Jorma Järvi. Implemented according to Järvi's design, Jyväskylä, Finland 1957.
- Viitatorni high-rise block, Jyväskylä, Finland 1957–61.
- Kampementsbacken housing area competition 1957, Stockholm, Sweden. Not built.
- Art Museum, Aalborg, Denmark, competition 1958, in collaboration with Elissa Aalto and Jean-Jacque Baruël. Built 1966–1972. **13**
- 'Neue Vahr' apartment building, Bremen, Germany 1958–62.
- Residential and commercial buildings, Rovaniemi, Finland 1958–63.
- Town hall, Seinäjoki, Finland 1958–60.
- Cultural centre, invited competition entry, Wolfsburg, Germany 1958–62.
- Karhusaari and Hanasaari. Area plan and standard houses, Espoo, Finland. Project 1959.
- Opera House competition, Essen, Germany 1959. Built 1983–88.
- Enso-Gutzeit company, Head offices, Helsinki, Finland 1959–62. **14**
- Central area plan, Helsinki, Finland 1959–62. Not implemented.
- Church and parish centre, Wolfsburg, Germany 1959–62. **15**
- Building for Union Bank of Finland, Helsinki, Finland 1960–65
- Municipal library, Seinäjoki, Finland 1960–65. **16**
- Harjuviita apartment buildings, Espoo, Finland 1961–67.
- 'The Academic Bookstore', Helsinki, invited competition 1961. Built 1966–69. **17**
- Institute of International Education, interior design, New York, USA 1961–65.
- Rovaniemi library, Finland 1961–6
- Seinäjoki theatre, Finland 1961–69/1984–87.
- Västmanlands-Dala students' association building, Uppsala, Sweden 1961–65.

- Finlandia Hall, Helsinki, Finland 1962, 1967–71/1973–75. **18**
- Scandinavian House (Nordic House),
 Reykjavik, Iceland 1962, 1965–68/1970–71. **19**
- Government offices, Seinäjoki, Finland 1962.
- Parish centre, Detmerode, Germany 1963–68.
- Row houses, Pietarsaari, Finland 1963
- Town centre, Rovaniemi, Finland 1963–65.
- Town hall, Rovaniemi, Finland 1985–88.
- Administrative and cultural centre, Jyväskylä, Finland 1964.
 Partly built: Police headquarters 1966–70, Theatre 1977–82.
- Schönbühl apartment building,
 Lucerne, Switzerland 1964–67.
- Library for Benedictine monastery,
 Mount Angel, Oregon, USA 1964, 1967–70. **20**
- Villa Aho, Rovaniemi, Finland 1964.
- Ekenäs Sparbank, Tammisaari, Finland 1964–70.
- Office building of the Helsinki City electricity power company,
 Helsinki, Finland 1965–75.
- Villa Oksala, Korpilahti, Finland 1965.
- Town hall, parish centre and health centre,
 Alajärvi, Finland 1966–70.
- Church and parish centre,
 Riola di Vergato, Italy, 1966, 1975–80, 1993–94. **21**
- La Fortezza, arts centre, Siena, Italy. Project 1966.
- Villa Kokkonen, Järvenpää, Finland 1967–69.
- Schönbühl housing area and shopping centre,
 Lucerne, Switzerland. Project 1968.
- Church of the Cross, Lahti, Finland 1969–79.
- Lappia Hall, Rovaniemi, Finland 1969–76. **22**
- Villa Schildt (Villa Skeppet), Tammisaari, Finland 1970.
- Alvar Aalto Museum, Jyväskylä, Finland 1971–73.

TRANSLATORS NOTE

The choice of the title of this book, Alvar Aalto Apartments, has not been unproblematic. In the foreword, Peter Reed begins by stating: "People love to look at houses but not housing". As a book title, however, the term 'housing' would perhaps seem too vague. Yet the more precise term 'collective housing' carries different connotations in different circumstances; often strongly connected to mass or state-financed housing projects, and thus not necessarily suited to a high-rise block of luxury apartments, whose inhabitants would associate 'collective' with socialism. Again, there are also cultural differences between the British English term 'flat, hardly used elsewhere in the English-speaking world, and the more widely used American English term 'apartment'. The latter term is being taken more into use in British English, too, but usually to describe a more bourgeois home, as opposed to the more plebeian 'flat' increasingly associated only with state-financed housing. But this book also contains student dormitories, which don't naturally lend themselves to the term 'apartment'. We thank the numerous people we have consulted over this problem for their suggestions.

ACKNOWLEDGMENTS

We should like to express our gratitude to the National Council for Architecture for a scholarship which made it possible for us to travel to photograph and to study Aalto's various apartment buildings. We would also like to thank the Housing Foundation and Alvar Aalto Museum, as well as the Alvar Aalto Foundation and its staff, Mia Hipeli, Katariina Pakoma and Marjaana Launonen, who have eagerly helped with collecting drawings and photographs for this book. Thanks also to Kristiina Lehtimäki at Building Information Ltd, who has patiently brought this book to completion.

Special thanks go to those numerous people who have assisted on the photo-shoot locations, making it possible for us to gain new photographic material to enrich the book:

Harry Tapper, Jyväskylä
Maija and Arto Ylipiha, Sunila
Rurik Wasastjerna, Sunila
Mikko and Veera Laaksonen, Kauttua
David N. Fixler, Boston
Else and Pellervo Oksala, Helsinki
Jutta Strauss, Berlin
Doris Andersson, Avesta
W. Selinski, Bremen
Michele Merckling, Espoo
Ying Zhang, Espoo
Felix von Schumacher, Lucerne
Nicolas von Schumacher, Lucerne
Markku Komonen, Helsinki

Helsinki, 29.2.2004
Sirkkaliisa Jetsonen and Jari Jetsonen